CW00662345

O

COLOR IN DRESS.

A MANUAL FOR LADIES.

BY

W. AND G. AUDSLEY.

ADAPTED FROM THE LONDON EDITION.

PHILADELPHIA:
CURWEN STODDART & BRO.,
450, 452, AND 454 N. SECOND ST.
March 16, 1872.

18/2, Aug. 13.
Gift of
Hon. Chas. Sumner,
of Boston.
(H. U. 1830.)

PHILADELPHIA:
COLLINS, PRINTER.

THIS little work, by the brothers Audsley, has been received with such approbation in England, and has been acknowledged by leading artists and *modistes* to be so correct, that its reproduction in this country cannot fail to extend the domain of good taste and a knowledge of harmonious arrangement of colors. In this belief the work is submitted to our countrywomen.

To our Lady Friends

This Manual is

DEDICATED,

By

Curwen Stoddart & Bro.

ANNIVERSARY GREETING.

PHILADELPHIA, March 16, 1872.

This day, *Forty years ago*, the present DRY GOODS HOUSE of CURWEN STODDART & BROTHER opened upon the same site on which now stand the three buildings devoted to their business:

Nos. 450, 452, and 454 N. Second Street.

For the uninterrupted preference awarded them during that long period, the firm tender to the surviving patrons and to the present customers their very sincere thanks.

While the main object has been the prosecution of a successful business, the confidence so cordially extended to us has been of so gratifying a character as to make the discharge of our duties a pleasure rather than a toil.

To celebrate this day and reciprocate the advantages we have enjoyed, we invite our customers, and the public generally, to our stores on the SIXTEENTH DAY OF MARCH, 1872, and on the following MONDAY, THE EIGHTEENTH, when we shall offer our large and well-assorted stock to Retail Purchasers at a Discount of TEN PER CENT.

In the hope that all our old friends may make an effort to be with us on this occasion,

We remain, respectfully,

CURWEN STODDART & BROTHER,

450, 452, AND 454 N. SECOND ST.

(6)

COLOR IN DRESS.

Part First.

THE DRESS AND THE COMPLEXION.

IT is not the material worn, but the judicious choice of colors, which indicates the true lady. Beauty is often diminished by an improper selection and arrangement of the hues of the dress, while an increase of the natural charms may always be secured by the artistic ap-

(7)

plication and grouping of harmonizing tints. As nature has withheld from many the power of at once selecting such tints, we hope in some measure to make up for her parsimony by stating with brevity and simplicity the maxims which good taste lays down in this respect.

And first, it is necessary in the choice of colors for every lady to consider carefully which best suit her own complexion. In a general way we divide complexions into the *Blondes* and the *Brunettes.* Blondes, again, are either *fair* or *ruddy;* and brunettes *pale* or *florid.* We shall describe each of these in turn, and mention what colors are the most becoming.

THE FAIR BLONDE.

The *Fair Blonde* has a delicate white skin, light hair, ranging in color from golden hue to yellow or orange-brown,

and eyes of gray or light blue. This
type, in periods of buoyant health, may
have slight tones of rose on the cheeks,
and a richer tint on the lips.

Let us consider what is required to en-
hance the beauty of this type. In the
complexion itself rose-color or red is
wanting. The hair should have a more
decided hue, or, if its own hue is objec-
tionable, a change for the better is desir-
able. All this can be done by the proper
selection of color in dress.

Of all colors for the dress, *Green* is most
favorable to the *Fair Blonde*, because it
imparts to the delicate flesh white of the
complexion a tint of red, forming by
union an agreeable rose-color.

Delicate Green is most suitable, being a
good contrast both to the face and hair,
especially if the hair be golden, or incline
toward orange.

From this we learn that the most becoming colors to associate with green are red, orange, and gold-color. Green and gold form a rich harmony. A scarlet is more agreeable with green than a crimson-red; but if a red inclining to crimson be used, orange or gold-color should be added.

Green may be associated with shades of itself, but the combination is not effective unless enlivened by other harmonious colors.

A *Green* bonnet is suitable to the *Fair Blonde*; it may have a small proportion of rose-color in its trimmings associated with white, and a white feather. Too much white, however, with green, produces a cold effect, and therefore does not aid the fair complexion to the desired degree.

Orange or gold-color may be substituted for pink; so also may red; but neither must be placed in juxtaposition with the

face. A small proportion of orange in a green bonnet is to be recommended when the eyes of the wearer are blue.

A few shades of red, orange, and yellow-green (autumnal tints), when not too dark, improve a green bonnet. These shades may be introduced in the form of leaves.

Dark Green is not so favorable to the *Fair Blonde* as *Delicate Green;* being so dark in comparison with the complexion, it neutralizes its own influence—that is, as a green it gives its complementary color, red, and as a dark color it reduces the complexion by decided contrast. All dark colors have the latter effect on fair complexions.

Blue is highly favorable to the *Fair Blonde,* as it imparts an orange tint, which combines in an agreeable manner with the delicate white and flesh tints of the

complexion. The *Fair Blonde* has natu-
rally traces of orange color on the skin,
and an intensifying of this natural tint is
in most cases very pleasing. The blue
used must be light, and not too positive.

As blue is the perfect contrast of orange,
it agrees well with golden or orange-
brown hair. Thus it is that a blue head-
dress is so becoming on light hair. To
give proper value to blue by gaslight, a
little white or very pale blue is required
in juxtaposition. If green be introduced
in a blue headdress, in the form of leaves,
for instance, it should be placed as near
the face as possible. The most suitable
blue for the headdress of ladies with very
fair hair is sky-blue.

A *Light Blue* bonnet, for the reasons
given, is very suitable to the *Fair Blonde*.
It may be trimmed with white or black,
and small portions of yellow, orange,

straw-color, or stone-color, but must not be ornamented with purple or pink flowers, for both form harmonies with blue, and are unsuitable to fair complexions.

A *Turquoise Blue* bonnet may be trimmed with fawn, gray, drab, or nankin.

The colors particularly to be avoided by the *Fair Blonde* are *Yellow, Orange, Red,* and *Purple.* The latter may be used in its light shades of *Lilac,* but is even then trying to the complexion, although not to an important degree if separated from positive juxtaposition by an edging of tulle, or similar trimming.

The injurious influence of lilac is much lessened when associated with its harmonizing colors, such as cherry, scarlet, light crimson, gold, or gold-color. On no account must green be coupled with lilac, as it forms a positive discord.

A small proportion of light purple is

2

agreeable in a headdress for light hair, but must not be placed near the skin.

Neutral Colors accord well with a fair complexion; when not too dark, they, as a rule, give value to the natural complexion; when dark, they reduce the tone by contrast. The best neutrals for the *Fair Blonde* are *Gray, Fawn, Slate, Drab,* and some shades of *Brown*.

Before we proceed to treat of *Black* as regards its own value with the complexion, we may remark that, associated in trimmings (such as narrow ribbons, braided work, or lace) with any of the above colors, it has a tendency to heighten their effect, especially by gaslight. This is caused by the power black has to absorb light, particularly artificial light.

Black, although sad in its effect, and the acknowledged garb of mourning, is nevertheless highly favorable to a *Fair*

Blonde who has a considerable amount of healthy color, because it increases the rose of the complexion. It has a somewhat disadvantageous effect on pale skins, bleaching them by powerful contrast.

No delicate color can be associated with black without appearing lighter in tone.

To remove the gloomy or sombre effect of black, colors should be added in trimmings, such as the following: blue, cherry, drab, mulberry, or lilac. Cherry and lilac should be used very sparingly for fair complexions. White is suitable with black, but is cold and harsh without some color be added. Red must not be used with black, as it gives it a rusty tinge.

A *Black* bonnet agrees well with a fair complexion, and may be ornamented with white and rose-color, or with white alone. Rose must be kept well away from the

skin. White feathers are a great im-
provement to a black bonnet.

White is similar in its effects to black ;
it heightens the natural rose of the face
by contrast, and increases the paleness of
a pale skin by powerful reflection.

White is suitable to every complexion
which has an agreeable natural tone, but
perhaps to none more so than to the *Fair
Blonde* with a healthy color. Small quan-
tities of bright colors may be added to a
white dress with pleasing effect, and they
will not injure the complexion if kept
low down and well grouped.

We remarked that white increases the
paleness of a pale skin; this objectionable
influence may be considerably neutralized
by a green or blue wreath, brought well
towards the face.

A *White* bonnet, when made of semi-
transparent materials, such as tulle, crape,

or aerophane, is suitable to this type, and may be ornamented to advantage with white and blue flowers.

THE RUDDY BLONDE.

The *Ruddy Blonde* has a full-toned complexion, somewhat inclining to positive rose-red or carnation, with dark blue or brown eyes and brown hair. This type is much subject to an increase of color in times of exercise or excitement.

The colors described as suitable for the Fair Blonde are, generally speaking, suitable for the type now under consideration; but their tones, and in some cases their hues, must be altered.

As a rule, the *Ruddy Blonde* may use more freedom in the selection of colors than the Fair Blonde; her complexion, not being of so delicate a nature, is less sensitive. From the fact that the hair

2*

peculiar to this type is the medium be-
tween golden and black, and that the tints
of the complexion are high and positive,
rich and moderately dark colors in dress
are to be recommended.

As in the Fair type, *Green* is one of the
best colors for the *Ruddy Blonde*, but in
the present instance delicate green is not
so suitable as *Dark Green*. When the
complexion is of a light color, and can
receive more red without becoming over-
charged, a rich full-toned green may be
adopted, such as a grass- or moss-green,
which, although sufficiently bright to
yield color to the skin, is not a contrast
powerful enough to bleach it.

In proportion as the complexion in-
creases in color, a green of deeper hue
must be selected, and progress must be
made from the positive to the neutral
hues, such as sage, tea, or olive greens.

Deep neutral greens do not cast much red on the complexion, while they both harmonize with and reduce its natural tints.

The simple rule to be observed in the case of the *Ruddy Blonde* is—the paler her complexion the brighter must be the green of her dress; the rosier it is, the deeper and more neutral must the green be.

A *Bright Green* bonnet is highly suitable to the *Ruddy Blonde* whose complexion is not overcharged with rose. When highly colored, the effect of the green should be neutralized by the addition of rose, scarlet, orange, or white flowers. On the inside of the bonnet, these colored flowers should be surrounded with some gray or semi-transparent material, to prevent them from coming in contact with the skin. On the outside, it is advisable to use several dead-green tints, as autumn

leaves, with the flowers, particularly if orange and scarlet ones are selected. Rose-colored flowers harmonize better with bright yellow-green than with dead-green leaves.

Blue is advantageous to the *Ruddy Blonde*, giving the complexion an agreeable tint. The orange which blue casts upon the skin is not itself perceptible, as it unites with the rose and flesh tints, forming a fresh and healthy color.

Blue follows the same rule as green, that is, it must be used deeper with complexions of full color than with those of lighter tint.

The best colors to associate with rich blue are orange, salmon, and chocolate. Both white and black harmonize well with blue. For further information on this subject we must refer our readers to the following Part on Harmony.

A *Blue* bonnet agrees well with the *Ruddy Blonde*, and may be trimmed with black, white, or any of the above colors, in small quantities.

A *Blue* wreath or headdress suits full-toned brown hair well, giving it an increase of orange, which is one of its constituents.

The same colors must be avoided by the *Ruddy Blonde* that are pointed out as injurious to the *Fair Blonde*.

Perhaps of all colors the most difficult to introduce in dress is *Violet*, its effect upon the complexion being so unsatisfactory. It causes all skins to appear yellow, and none can receive that color without at once looking sickly and disagreeable.

A considerable proportion of yellow is required to neutralize violet and reduce its powerful effect.

A *Violet* bonnet, trimmed in front with

yellow and some semi-transparent mate-
rial, may be rendered pleasing.

As Violet becomes positively lost in
artificial light, it is totally unsuited to be
introduced in evening dress.

The *Neutral Colors* are generally suita-
ble to the *Ruddy Blonde.* When of me-
dium intensity, they leave the natural hue
of the complexion almost uninfluenced;
when light, they increase its color; when
dark, they reduce it by contrast. The
most agreeable dark neutrals are russet,
slate, gray, maroon, and all the hues and
shades of brown; the most pleasing light
neutrals are gray, drab, fawn, and stone-
color.

The remarks we made respecting *White*
and *Black*, in connection with the former
type, apply in every way to them in con-
nection with the *Ruddy Blonde.*

THE PALE BRUNETTE.

The *Pale Brunette* type has a pale skin, perhaps in some instances having a trace of sallowness, with dark brown hair, at times approaching to black, and eyes of a deep brown or brown-black hue.

The powerful contrast which exists between the tint of the complexion and the hue of the hair and eyes, shows that either light or very dark colors will suit the *Pale Brunette* better than medium tints—the light harmonizing with the complexion and the dark with the hair and eyes.

We thus follow Nature, adopting her own satisfactory coloring, and sustaining her effective contrast. The tints chosen as analogous to the complexion remain, like it, in contrast with the hue of the hair and eyes; those selected as analogous

to the latter sustain the contrast with the tint of the complexion.

To adopt colors of medium intensity between the skin and hair is injurious to the *Pale Brunette*, because they have a tendency to reduce the expression, which is the greatest charm of the type.

Black, analogous to the hue of the hair and eyes, is highly favorable to the *Pale Brunette*, contrasting in the most perfect manner with the complexion, as well as purifying and giving value to its natural tints.

Almost all the shades of *Dark Brown*, which stand, as far as analogy is concerned, in the same position in reference to the hair as black, are, like it, very suitable.

Claret, *Dark Russet*, and *Crimson* are suitable to this type, but not so much so as black or brown.

Dark Blue, Green, or *Violet* may be used, but not with complexions having the slightest trace of yellow. The nearer these colors approach black, the more suitable they become; positive, blue, green, or purple must be avoided.

White, analogous to the tint of the skin, is very favorable to the *Pale Brunette,* and enhances the richness of the hair and eyes. For evening wear nothing surpasses white, as it is rendered particularly pleasing by the yellow cast it receives from artificial light.

The union of yellow and white is agreeable for evening dress, lighting up well; but it is dull and poor for day costume.

Gold-color or *Maize* is most suitable to the *Pale Brunette;* it forms an agreeable contrast to the eyes and hair, deepening their tone; and it neutralizes any unplea-

3

sant sallowness which may exist in the complexion.

THE FLORID BRUNETTE.

The most perfect of all the types of female beauty is that of which we are about to speak.

The *Florid Brunette* has a rich-toned skin, inclining in some cases to the olive, in others to the copper-colored complexion, with more or less deep redness about the cheeks and lips. The eyes of this type are black, the hair a jet or blue black.

The complexion peculiar to the *Floria Brunette* may be said to consist of a light subdued yellow or orange-brown, and the portions which display color are more of a positive red than a rose color, as in the Blonde types.

We may observe that in the complexion of this type tones of yellow, orange,

and red predominate, which harmonize together by analogy, and with the hair and eyes, which are black, by contrast.

As the *Florid Brunette* displays naturally an agreeable group of harmonizing tints, care must be taken not to weaken the harmony by the use of objectionable colors. At the same time, it is advisable to neutralize any unpleasant tint which the complexion may contain, such as too much yellow, which has a decided tendency to give a sallow and unhealthy cast to the skin.

Yellow, Maize, and *Gold-color* suit the *Florid Brunette,* because, while they contrast in a highly favorable manner with the hair and eyes, intensifying them by the addition of purple, they harmonize by analogy with the tints of the complexion, and neutralize, to a considerable de-

gree, any superabundance of yellow they may naturally contain.

When the complexion displays more orange than yellow in its tints, an increase of red is given to it by the use of yellow or maize in dress.

A *Yellow* bonnet is favorable to this type; but, as it approaches near to and surrounds the face, it should have a considerable proportion of its influence neutralized; this may be done by the introduction of violet, purple, or deep blue flowers, kept away from contact with the skin. These flowers must be used very sparingly.

Orange, although it may be said to suit Brunettes with more or less positive orange in their complexions, is too brilliant and gaudy to be used in dress, save in very small proportions.

Red, Scarlet, Bright Crimson, Magenta,

and all brilliant colors of the like class, follow the same rule as orange, suiting some complexions containing red, which it is advantageous to neutralize, but being too bright for general costume.

A *Scarlet* headdress is particularly suitable to black hair, intensifying it by contrast, and by the addition of a purple hue.

Dark Red is favorable to complexions which have too much natural red, because, besides its tendency to neutralize the color of the skin, it reduces it by contrast.

Violet is unsuitable to the *Florid Brunette* unless its injurious influence be destroyed by the addition of yellow. Very dark violet is not so objectionable as the positive color.

A *Violet* bonnet may be rendered very pleasing by being trimmed with a quantity of pale yellow flowers, such as primroses. The flowers contrast with the

3*

violet of the bonnet, and accord well with the complexion.

Most medium-toned *Neutrals,* such as *Brown, Slate,* and *Gray,* are unfavorable to this type; the very darkest shades of these colors, however, are suitable to some full-toned complexions. *Silver Gray* is also suitable to complexions with a moderate amount of color.

Black contrasts well with the complexion of the *Florid Brunette,* although not so perfectly as with that of the previous type. It enhances the red by reducing the lighter tints of the skin; but it has no power to neutralize any objectionable color that may exist.

A *Black* bonnet, although not so suitable to the Brunette as to the Blonde, is, nevertheless, agreeable in its effect. It may be ornamented with white, red, orange, or yellow trimmings.

White is more favorable to the *Florid Brunette* than black, and accords well with all complexions. A white dress may be ornamented to advantage with scarlet, orange, or yellow.

A *White* bonnet, which is highly suitable to this type, should have trimmings of red, orange, or yellow; red or orange is to be preferred, yellow and white having a weak effect by daylight.

Part Second.

HARMONY OF COLOR.

IN the present part of our Manual we intend to make a few remarks relative to the grouping of color with color.

In costume, nothing is more common than to see tints employed together which are discordant: for example, purple and green. Now, be the dress or bonnet ever so well made, and the wearer ever so beautiful, the effect of such ignorance will be unpleasant in the extreme.

Every color has its perfect harmony, which is called its contrast, and also other colors which harmonize with it in differ-

ent degrees. When two colors are asso-
ciated which do not accord, the addition
of a third may make a harmonious group.
The same rule holds good with three or
more colors.

There are two kinds of harmony ac-
knowledged in the grouping of colors,
namely, the *harmony of contrast* and the
harmony of analogy.

When two colors which are dissimilar
are associated agreeably, such as blue and
orange, or lilac and cherry, they form a
harmony of contrast. And when two dis-
tant tones of one color are associated, such
as very light and very dark blue, they
harmonize by *contrast.* Of course, in the
latter instance the harmony is neither so
striking nor so perfect.

When two colors are grouped which
are similar to each other in disposition,
such as orange and scarlet, crimson and

crimson-brown, or orange and orange-
brown, they form a *harmony of analogy.*
And if two or more tones of one color be
associated, closely approximating in inten-
sity, they harmonize by *analogy.*

The harmonies of contrast are more
effective, although not more important,
than those of analogy; the former are
characterized by brilliancy and decision,
while the latter are peculiar for their
quiet, retiring, and undemonstrative na-
ture. In affairs of dress both hold equal
positions; and in arranging colors in cos-
tume, care must be taken to adopt the
proper species of harmony.

The simplest rules to be observed are
the following: 1st, When a color is se-
lected which is favorable to the complex-
ion, it is advisable to associate with it tints
which will harmonize by analogy, because
the adoption of contrasting colors would

diminish its favorable effect. 2d, When a color is employed in dress which is injurious to the complexion, contrasting colors must be associated with it, as they have the power to neutralize its objectionable influence.

We will take an example illustrative of the first rule. Green suits the blonde, and, when worn by her, its associated colors should be tones of itself (slightly lighter or darker), which will rather enhance than reduce its effect.

As an example of the second rule, we may take violet, which, although unsuitable to brunettes, may be rendered agreeable by having tones of yellow or orange grouped with it.

Colors of similar power which *contrast* with each other mutually intensify each other's brilliancy, as blue and orange, scarlet and green. When dark and very light

colors are associated, they do not intensify
each other in the same manner; the dark
color is made to appear deeper, and the
light to appear lighter, as dark blue and
straw-color, or any dark color and the
light tints of the complexion.

Colors which harmonize with each
other by *analogy* reduce each other's bril-
liancy to a greater or less degree; as white
and yellow, blue and purple, black and
brown.

In dress it is objectionable to associate
together different hues of one color; for
instance, yellow-green and blue-green, or
orange-brown and purple-brown. Care
must therefore be taken in selecting differ-
ent tones of a color to see that they belong
to the same scale.

There is another fact we wish to bring
before our readers ere we close our re-
marks on the harmony of color, namely,

that tints which accord by daylight may appear unharmonious by artificial light, and *vice versa;* thus, purple and orange harmonize by day, but are disagreeable by gaslight; and white and yellow, which are unsatisfactory by daylight, are suitable for evening dress.

There are many colors which lose much of their brilliancy and hue by gaslight, and are therefore unserviceable for evening costume; of this class we may enumerate all the shades of purple and lilac, and dark blues and greens. Others gain brilliancy in artificial light, as orange, scarlet, crimson, and the light browns and greens. It is advisable that all these circumstances should be considered, in the selection of colors for morning and evening costume.

Our readers will find the following list of harmonious groups of service in the

4

arrangement of colors in dress; we have
given the most useful as well as the most
agreeable combinations.

Blue and gold (or gold-color), a rich harmony.
Blue and orange, a perfect harmony.
Blue and crimson harmonize, but imperfectly.
Blue and pink, a poor harmony.
Blue and salmon-color, an agreeable harmony.
Blue and lilac, a weak harmony.
Blue and drab harmonize.
Blue and stone-color harmonize.
Blue and fawn-color, a weak harmony.
Blue and white (or gray) harmonize.
Blue and straw-color harmonize.
Blue and maize harmonize.
Blue and chestnut (or chocolate) harmonize.
Blue and brown, an agreeable harmony.
Blue and black harmonize.
Blue, scarlet, and purple (or lilac) harmonize.
Blue, orange, and black harmonize.
Blue, orange, and green harmonize.
Blue, brown, crimson and gold (or yellow) harmonize.
Blue, orange, black, and white harmonize.
Red and gold (or gold-color) harmonize.
Red and white (or gray) harmonize.

Red, orange, and green harmonize.
Red, yellow (or gold-color), and black harmonize.
Red, gold-color, black and white harmonize.
Scarlet and purple (or lilac) harmonize.
Scarlet and blue harmonize.
Scarlet and orange harmonize.
Scarlet and slate-color harmonize.
Scarlet, black, and white harmonize.
Scarlet, blue, and white harmonize.
Scarlet, blue, and gray harmonize.
Scarlet, blue, and yellow harmonize.
Scarlet, blue, black, and yellow harmonize.
Crimson and gold (or gold-color), a rich harmony.
Crimson and orange, a rich harmony.
Crimson and maize harmonize.
Crimson and purple harmonize.
Crimson and black, a dull harmony.
Crimson and drab harmonize.
Crimson and brown, a dull harmony.
Yellow and purple, an agreeable harmony.
Yellow and blue harmonize, but cold.
Yellow and violet harmonize.
Yellow and lilac, a weak harmony.
Yellow and chestnut (or chocolate) harmonize.
Yellow and brown harmonize.
Yellow and red harmonize.
Yellow and crimson harmonize.
Yellow and white, a poor harmony.

Yellow and black harmonize.

Yellow, purple, and crimson harmonize.

Yellow, purple, scarlet, and blue harmonize.

Green and gold (or gold-color), a rich harmony.

Green and yellow harmonize.

Green and orange harmonize.

Green and scarlet harmonize.

Green, scarlet, and blue harmonize.

Green, crimson, blue, and gold (or yellow) harmonize.

Orange and chestnut harmonize.

Orange and brown, an agreeable harmony.

Orange, lilac, and crimson harmonize.

Orange, red, and green harmonize.

Orange, blue, and crimson harmonize.

Orange, purple, and scarlet harmonize.

Orange, blue, scarlet, and purple harmonize.

Orange, blue, scarlet, and claret harmonize.

Orange, blue, scarlet, white, and green harmonize.

Purple and gold (or gold-color), a rich harmony.

Purple and orange, a rich harmony.

Purple and maize harmonize.

Purple and blue harmonize.

Purple and black, a heavy harmony.

Purple and white, a cold harmony.

Purple, scarlet, and gold-color harmonize.

Purple, scarlet, and white harmonize.

Purple, scarlet, blue, and orange harmonize.

Purple, scarlet, blue, yellow, and black harmonize.

Lilac and gold (or gold-color) harmonize.
Lilac and white, a poor harmony.
Lilac and gray, a poor harmony.
Lilac and maize harmonize.
Lilac and cherry, an agreeable harmony.
Lilac and scarlet harmonize.
Lilac and crimson harmonize.
Lilac, scarlet, and white (or black) harmonize.
Lilac, gold-color, and crimson harmonize.
Lilac, yellow (or gold), scarlet, and white harmonize.
White and gold-color, a poor harmony.
White and scarlet harmonize.
White and crimson harmonize.
White and cherry harmonize.
White and pink harmonize.
White and brown harmonize.
Black and white, a perfect harmony.
Black and orange, a rich harmony.
Black and maize harmonize.
Black and scarlet harmonize.
Black and lilac harmonize.
Black and pink harmonize.
Black and slate-color harmonize.
Black and brown, a dull harmony.
Black and drab (or buff) harmonize.
Black, white (or yellow), and crimson harmonize.
Black, orange, blue, and scarlet harmonize.

Part Third.

THE EXPRESSION OF COLORS.

THERE is a language of colors. They speak to the eye as strains of music to the ear, and produce in us peculiar trains of ideas and sentiments. A witty Frenchman says that he noticed quite a change in his wife's conversation when he furnished her rooms in crimson in the place of blue. We will briefly mention what effect is exerted on the mind by each of the primary and secondary colors —blue, red, yellow, orange, purple, and green.

BLUE is a cold and retiring color, and

its effect upon the mind is of a quiet, soothing, yet attractive nature. Goethe remarks: " As the high heavens, the far-off mountains, look to us blue, so a blue superficies seems to recede from us. As we would fain pursue an attractive object that flees from us, so we like to gaze at the blue—not that it urges itself upon us, but that it draws us after it." It is symbolical of divinity, intelligence, sincerity, and tenderness.

> " Long, Pity, let the nations view
> Thy sky-worn robes of *tenderest blue.*"
> COLLINS.

In accordance with the law of contrast, blue is most suitable for summer costume, being peculiarly a winter color, and by nature cold and retiring.

RED is a strong, ostentatious, and warm color ; and, being so beyond every other,

it is therefore the fit symbol of war, pomp, and power.

"While Mars, descending from his *crimson* car,
 Fans with fierce hands the kindling flames of war."
<div align="right">HALLER.</div>

"Thy ambition,
Thou *scarlet* sin, robbed this bewailing land
Of noble Buckingham."
<div align="right">SHAKSPEARE.</div>

From its hot and fiery nature, it is expressive of anger and the ardent passions.

"Change the complexion of her maid-pale peace
 To *scarlet* indignation."
"Beaufort's *red* sparkling eyes blab his heart's malice."
<div align="right">SHAKSPEARE.</div>

"Spreads the *red* rod of angry pestilence."
"Celestial *rosy red*, Love's proper hue."
<div align="right">MILTON.</div>

Of all colors, red and its modified hues are most suitable for winter costume. The warm, pleasing effect of a scarlet cloak on a cold winter day is well known.

Yellow is the color nearest approaching to light, and is most advancing and brilliant, either alone or in connection with other colors. As a rule, positive yellow should be sparingly used in dress, preference being given to its modified hues, such as gold-color, maize, and primrose. Yellow is the common symbol of envy and other malignant passions. Shakspeare, alluding to jealousy, says—

"I will possess him with *yellowness.*"

"And Jalousie,
That wered of *yelw* colors a gerlond."

CHAUCER.

The effect of yellow upon the mind is of a bright, gay, gladdening nature, owing to its likeness to light, both natural and artificial. Yellow is sometimes employed to express the richness of autumn, and also the season itself, although deeper and richer colors are more suitable, as russets and browns.

"Two beauteous springs to *yellow* autumn turned."
<div align="right">SHAKSPEARE.</div>

"The *yellow* harvest's countless seed."
<div align="right">BYRON.</div>

In dress, yellow is most suitable for spring and early summer.

ORANGE is a warm, prominent color, and both in nature and art appears to the best advantage when in small quantities, and associated with its contrasting colors, blue and purple. Orange is the medium color between red and yellow, being produced by a union of both, and is similar to them in its properties and expression.

In dress, orange is most suitable for winter or very early spring.

PURPLE is the most retiring of all rich colors; it is composed of red and blue, but is not their medium color, being heavier in its effect than the latter. Purple is symbolical of dignity, state, and

regal power; it is a color frequently adopted for mourning, and is expressive of gravity, sorrow, and sadness.

"The pale violet's dejected hue."
AKENSIDE.

"Shall we build to the *purple* of pride?"
KNOWLES.

Purple is suitable for winter, spring, and autumn costume.

GREEN is a cool, calm, and refreshing color. It is composed of blue and yellow, and holds a medium station between them. To the human eye there is no color so grateful as green, being a temperate and retiring, as well as a most beautiful and cheerful color.

Green is the peculiar garb of spring. Nature displays it at that season alone in freshness and vigor. It is the symbol of youth, mirth, hope, gladness, tenderness, and prosperity.

"While virgin Spring, by Eden's flood
Unfolds her tender mantle *green*."
<div align="right">BURNS.</div>

" The violets now
That strew the *green* lap of the new-come spring."
<div align="right">SHAKSPEARE.</div>

" That yon *green* boy shall have no sun to ripe
The bloom, that promiseth a mighty fruit."

" My salad days,
When I was *green* in judgment."
<div align="right">SHAKSPEARE.</div>

" The *green* stem grows in stature and in size,
But only feeds with hope the farmer's eyes."
<div align="right">DRYDEN.</div>

Green is most suitable for late summer
or autumn costume, being fresh and
grateful at a season when Nature arrays
herself in bright and burning colors.

Family Dry Goods Store

Established March 15, 1835

Nos. 450, 452 & 454 N. Second St.

PHILADELPHIA

Lightning Source UK Ltd.
Milton Keynes UK
UKHW050024130223
416651UK00005B/32